# Because real life doesn't rhyme

Pallavi Parihar

BookLeaf Publishing

Because real life doesn't rhyme © 2022
Pallavi Parihar

Presentation by *BookLeaf Publishing*

Web: www.bookleafpub.com

E-mail: info@bookleafpub.com

ISBN: 978-93-95088-20-6

First edition 2022

# DEDICATION

This book is for Aarav. Welcome to the world, little Prince.

# ACKNOWLEDGEMENT

To feel the depths of our emotions is both a gift and a curse. To learn to swim, and not drown in them, is a skill. To have people who willingly hold you up when you have the energy to do neither, is a blessing. Thank you to all my angels who tirelessly offer their shoulder to lean on, on the days it all feels like too much, and have never ceased to believe in my ability to shine, even on the days when I was blind to it myself.

Special thank you to my family. Mum, Papa, Aashima. Not everyone is as blessed and lucky as I have always been, to dream a dream and see it come true. For every opportunity, for every lesson. I owe it all to you.

# Because real life doesn't rhyme

When the world becomes incompatible
Fraught with feelings I can't comprehend
I find solace in my ink and pen
These words become my friend

They have the power to unleash my soul
Bring to life once stagnant passions
In these pages once again I'm alive
No longer razed by my reactions

A verse, it has some sweet magic
To heal a broken heart
Make light of troubles arduous
Inspire a new start

These pages willingly absolve me
Of my guilt and worn regret
The future stops intimidating
The past I can forget

In a couplet inspiration is born
A chance encounter becomes fate
'Cannot' is reduced to just a rhyme
Destiny becomes yours to create

No matter what life unveils to me
I know that I'll be fine
I'll find solace in my ink and pen
Because real life doesn't rhyme

# For Aarav

If I could give you just one piece of advice
Gosh, I don't even know where I'd begin
If I could go back in time, not one thing would I
change
My dear, I would do it all again

There were times I followed my heart and got hurt
Times my decisions resulted in pain
Times I did nothing, and still bore the brunt
But, my dear, I would do it all again

I'd still love that boy though he would break my heart
I'd still take that wrong turn, end up lost in the rain
I'd still dance in the meadows while others would
laugh
Oh if I could, my dear, I would do it all again

Too often I wished away the moments of sadness
Rushed down the path eager to get to the end
I wish I'd walked slower, breathed deeper, laughed
louder
If only, my dear, I would do it all again

I'd revisit the peaks that I'd turned from in fear
Follow dreams that had felt unrealistic back then
Dive into the abyss, not knowing my way back
With you, my dear, I would do it all again

One piece of advice, dear, embrace all your dreams
You will get things wrong, but don't be afraid
If you fall, always know we'll be right here to catch
you
For you, my dear, I would do it all again

# I shall let my hair curl

My hair, it's rather stubborn
You see, it doesn't know
The rules of your conformity
Your inherited fearful woe

It flouts your need for consistency
Rebels against being told to comply
Doesn't flinch in the face of cruelty
When told that it doesn't satisfy

My hair, it boldly curls and shines
Unafraid to take up space
Firmly choosing the direction
It knows it was born to take

Unapologetic in its difference
Unwilling to compromise
You see, it doesn't understand
Your need to bureaucratise

I surrender to its individuality
It is none of my concern
If you balk at its tenacity
I shall let it damn well curl

# Mistaken enemy

Taught to hate each other
Divided by jealousy and distrust
Made to compare and compete
Replace encouragement with disgust

We should have been comrades in arms
We share the same cursed plight
Once revered, now relegated
It's on the same side that we fight

As one we would be stronger
I guess that was their concern
Together we're uncontainable
And so instead they watched us burn

They should've worshipped at our feet
Bowed down to our femininity
Respected in us their counterpart
Acknowledged our divinity

I withdraw from this false battle
Outraged! I refuse
To see you as my enemy
Unity is what I choose

I will raise up your accomplishments
Applaud your intuition
Praise your beauty, unthreatened
March against our abolition

I offer you my devotion
To undo their past misdeed
Endeavour to make up for lost time
Sisters! It's time we take the lead

# Dear neighbour

Why don't you rest a while?
Whilst I shelve your doubts away
Let me hold on to your grief for now
You've been carrying it all day

I may not have the answers
But my ears they never tire
Though I cannot vow to don your shoes
I'll walk beside you, if you desire

Alas, if I could wish away
Your burdens, trust that I would
But why not put them down with me
While you toil, they do no good

You do not have to hide your pain
There's magic when you share
You do not have to fight alone
Take heed, there's those who care

It is my fortune to sit beside you
Costs me nought to understand
If my feet fall short of helping
I'll offer you my hand

Don't be afraid to call my name
By your side is where I'll be
There's no dishonour in feeling
Tomorrow, it could be me

# Unconditional

I love you for your kindness
Seeking nothing in return
I love your true compassion
Your easy, genuine concern

I love you for your patience
So laid-back in your approach
Except when faced with injustice
Boldly met with your reproach

I love your thirst for knowledge
Always striving to expand
I love your daring spirit
Our adventures hand in hand

I even love your temperament
Never knowing when you'll sigh
Or burst into joyous laughter
Or how they sometimes coincide

I love you for your worries
I sometimes worry too
But I know there's nothing we can't face
Together, me and you

I love your vulnerability
Even when you try to hide
Your inability to admit your wrong
Even love your stubborn pride

I love you with a ferocity
Even when you act unconcerned
I love you with the depths of my soul
Even when that love is not returned

I love your fears, your faults, your scars
I love your imperfections
I still love you when you disappear
Love you through your waned affections

I love you unconditionally
But you see, I love me too
I love you enough to walk away
We both have some healing to do

I love you from a distance
Hoping one day we'll meet anew
My love, even if I stay apart
Please remember, I love you

# Forgiveness

Innocent. Unwitting.
Unprepared for your betrayal
I blindly followed where you led
Never dreamed my trust could fail

Now trapped behind these barbed wire walls
A cage of my own making
Impenetrable, unyielding
To keep my heart from breaking

Afraid of my own shadow
Second-guessing my every choice
Your selfishness taught me to be small
It's safest when I have no voice

Now I'm left with these open wounds
The bruises may fade with time
I may have learned to walk again
But it doesn't erase your crime

How can I ever just 'let it go'
Pretend that I'm alright
When every second I'm left broken
Your words still haunt me every night

I'm exhausted holding on to hating you
Tired fighting for the pride I lost
Every day I've stoked my vengeance
Fed my anger. But at what cost?

I've burned my hands on this hot coal
Sipped too long from this bitter chalice
Deprived myself trying to punish you
In the absence of justice, settled for malice

I'm taking back my power
Letting go of your deceit
I forgive you for your cowardice
Your promises left incomplete

It is my benevolence to understand
You gave me all you 'could'
But it was less than what was my right
Deficient in what you 'should'

It's time at long last I free myself
I've realised it was never about me
I forgive you, finally, not for you
I forgive you. For me.

# The Heist

"heist definition: 1. a crime in which valuable things are taken illegally and often violently from a place or person" – Cambridge English dictionary

Door left ajar
Empty corridor
Silence ringing

Discarded
Waiting for an answer
Uncomprehending

Why?

The thoughts
Swarm, unbidden
Pointing, mocking
An unrelenting assault

Wrists blistered
By invisible shackles
Of my own making

Clutched in my fingers
The key
Made useless by the lies
My past whispers to me

A step forward
No, only imagined
Triggering a flood
Of what ifs
That chase me back
Into the cold embrace
Of apathy

A crumpled map
Of half-riddled answers
Highlighting my incapacity

You see
I was never taught
To read a map
And that burden somehow
Falls on me

Every now and then
A memory flitters
To the surface
Fleeting in its
Vibrancy

Of a time when
The word 'fear'
Was unknown to me
A time when I trusted
A time when I believed
Before
It was stolen from me.

# The bird on the branch

Born worthy, destined for greatness
Deserving of whatever I may want
Loved, blessed, protected
But somewhere, I forgot

With this broken world my template
A mask of adequacy as my disguise
Mimicking the conditions
The timid cling to, to survive

I must succeed to stay afloat
To have all the answers is my duty
I must ensure I never fail
I must show others I have beauty

Diverging from this plan brings danger
Brings the threat of isolation
Runs the risk of being left without
Heralds the pain of desolation

I learned the rules I needed
To earn my joy and love
Ignorant and unaware
That I was already enough

I release the false safety of control
Contingencies do not break me
I can only lose what isn't mine
My appearance does not make me

I meet the unknown of tomorrow
Not afraid of what it brings
Safe to rest a moment on this branch
For I remembered, I have wings

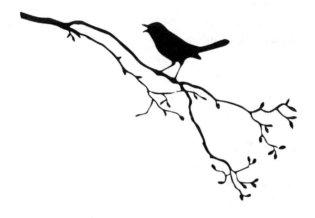

# Beggar

An addiction. An obsession
Bound by the fear
Of being left without

This pain a preview
Of my imagined devastation
If forever were to run out

A hunger, longing
Craving safety
Ruled by famished need

How foolish
I mistook for love
An absence unfulfilled

Pleading for alms
Settling for scraps unfitting
Of what I'm truly worth

One day I will love
An empowered love.
A love not led by dearth

Love cannot be bartered
Does not deal
In destitution

One day I'll be the King
I was born to be
Demanding retribution

# A fool's game

A hand outstretched, seeking compassion
A need to be seen; that's all. It's free.
Asking nought to give; rather to stop taking
Simply pleading, 'let me be me'.

Does my courage challenge your safety?
Threaten your sense of who you ought to be?
I will not peel my skin to shelter yours
All I have to give you is my pity

I am not obliged to protect your ego
When it's me you weaponise it against
I owe no kindness to your cowardice
Foolishly triggered by my mere presence

I think you are mistaken
If you think I give a damn
To care for your approval
Or your likes on Instagram

My curves remain impervious
To your assessment, you can keep
My body will continue miraculous
To climb, to sway, to leap

My joy unadulterated
My success tastes just as sweet
Un-embittered by your disdain

If your 'standards' they don't meet

It is not my obligation
To please your desire for control
To pander to your broken sense
Of what's needed to feel whole

No longer will I play pretend to please you
No longer will I deign to dim my shine
Gone are the days of culling my shadow
No longer will I beg for what is rightfully mine

I won't silence my words. Engrave them.
So ends this eternal abuse
I will not surrender to your insecurities
I will live however I so choose.

You can't stop my feet from climbing
With your hurdles of bid shame
There's somewhere else I need to be
I refuse to play your game

# The Battle

She crawls into my bed at night
Holds me close, whispers in my ear
Promises to keep me safe
Preserve all that I hold dear
If I dare step out of line
She reminds me of life's perils
The risk of failure, the threat of loss
The struggle that 'trying' entails
She only wants what's best for me
To these rules I must adhere
I call her 'logic', or 'rationality'
Sometimes, I call her 'Fear'.

He is the shadow clutching at my chest
Squeezing when I step out of place
I am his mistress of my own choosing
Habituated to his angry embrace
He reminds me I'm not good enough
My life's desires aren't real
His raised voice helps keep me small
My flaws I must conceal
Without his armour I'd be exposed
There's an image I must maintain
Alas, if someone saw within
They'd ask "have you no Shame?"

I tore away sweet Fear tonight
Ripped her cruelly from my bosom

When dear Shame stepped in to fight
I held his darling ego ransom
They dragged me through the filth of my past
Ravaged the very core of my being
Laughed at my deepest hidden doubts
Used my hissed failures as their weapon
I hit back at them with dormant Pride
Unearthing Faith to meet their hate
Bored with my growing resolution
They finally left me to my fate

Night has come, I am alone
No fear to hold my hand
Without shames armour, feeling raw
This sovereignty unplanned
Desire knocks. No answer
I'm wisened to her betrayal
Opportunity meets the same fate
Her promises left pale
Foolish in their fantasy
I can see what they won't say
They come, they knock, I'm shrewder
I know they'll never stay

From the darkness a new voice emerges
Tender, timid. I hold her back
Distrusting of her promises
Prepared for her attack
She is patient. Encouraging
Gently trying to evoke
I call her 'foolish', or 'naïve'
Sometimes, I call her Hope

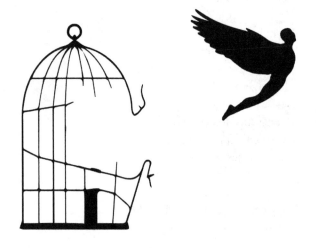

# Empty Vessel

Lifeless, cold. An empty vessel
Don't have it in me to try
A carcass ravaged for all its worth
No pride left to dignify

I tore off pieces of me to feed you
And now I'm struggling to survive
Met with backs all turned away
A solitary crusade to stay alive

Shoulders once praised for bearing tears
Marked with the shadows of footprints
Arms that engulfed a valley of fears
Purpose served, abandoned since

The pause between 'too' and 'trusting'
The cavernous home of sin
The scales of justice served with kindness
The battle you can never win

Come, plunder the barren depths of me
Bleed my nectar till it runs dry
Ignite my bones to keep you warm
Use my tears as your lullaby

Crushed beneath one lapse in judgement
Forever tainted by the dye of shame
Another relic for my wreckage
How did I go wrong, again?

Inimitability both my gift, and curse
My very breath, somehow wrong
Haunted by the persistent feeling
I never did, and never will, belong

# Eclosion

I have mastered the art of creation
Cultivated a place I call my haven
Here I grow, I rest, I flourish
Concealed in my imagination

In this garden, I have transformed
Vanquished my demons, conquered my fear
Safely ensconced, I can now rest easy
A place I can disappear

"My child, you have now long rested
You've grown stronger, you've grown wiser.
Now, go! It's time to experience the world
Chase adventure, pursue desire"

I shook my head, "It's not quite the right time
I have everything I need right here.
Why would I venture away from this shelter
When I already possess all I hold dear"

Spring arrived, buds turned to bloom,
I sat in my stillness, safe and content
Seasons drifted, still I stayed quiet
The leaves turned crisp, the air grew stagnant

"My child, you've reposed, the moment has come.
It is time to expand out of your comfort zone"
"Not yet." I refused. "I must have more time.
It isn't quite safe to venture out on my own."

From autumn to winter, leaves coated in ice
"Reconsider, my child, for what is it you wait?"
I looked out beyond the walls of my garden
"I'm just not ready to open the gate"

Morning dawned, bringing with it a calling
Purpose flowed in my veins, new colour unfurled
I see a new path emerge beyond the horizon
It's time. I'm ready to step into the world.

# I'm Sorry

I'm sorry for the things I said
Trying to cause you shame
An enemy created by
The mirage of my own pain

I'm sorry that I blurred the bounds
Of what I was willing to accept
And blamed you for your unwitting invasion
Borne by my self neglect

I'm sorry for ever hurting you
I was hurting too.
I bled on you, an unhealed wound
But that is no excuse

I'm sorry that I played pretend
Never showed you the real me
Disbelieving you could ever love
When I had never learned to receive

I'm sorry that you're not here, and I'm not there
That 'we' no longer exist
I'm sorry I could not find the courage
To let our love persist

But most of all I'm so, so sorry
For all the times I didn't say
'I love you, now, forevermore'
And now, the price I pay

# Letter to a Ghost

I am not this girl
Waiting at the window
Listening for the rhythm
Of my phone
Hoping, wishing, praying
It may be you

Running through my memories
What I said,
What I wore,
How I behaved
Where did I go wrong?

Was I wrong?
Why was I wrong?
Why isn't this wrong?
Why aren't you wrong?

What gives you the right
To play King Lear
Bequeathing your love
As if I don't matter

Talk to me, answer me
Show me a sign
I'm going crazy
Can't let go of this

Desperation
THIS ISN'T ME

I am not this girl
I am not your plaything
I am worth so much more

Am I telling you?
Or am I
Telling me

# A rose by any other name

I happened upon a rose today
Whose beauty filled me with delight
I thought to myself, how lucky I am
To be blessed with such a sight
A once mundane, ordinary day
Was suddenly transformed
The sky grew bright, birdsong sweeter
My maladies reformed

But alas, upon closer inspection
I realised I had been misled
What I had first perceived a rose
Was a wisp of plastic instead
Dumbstruck, perplexed, overwhelmed
I found myself suddenly robbed
Of the goodwill and merry attitude
My false perspective had begot

If a ball of fire in the sky
A guiding light can be
And a clover made of four leaves
An omen of prosperity
Then surely it is within my gift
To declare, and reclaim that joy
That, at least from my perspective,
I happened upon a rose today

# Chrysalis

An unlit match, I am set ablaze
A bud yearning to bloom
A hermit content in tranquillity
Now longing to be consumed

Unparalleled attraction
A draw I could not resist
But your only purpose was to reflect
My potential I had dismissed

I had grown too comfortable
With "I can't", "it won't", and "never"
But this push and pull forced me to see
You were never my endeavour

In your mirror of rejection
You revealed to me the cracks
That needed my attention
Where I had created lack

In your blind eyed stare, I saw reflected
The unacknowledged shine
Of all I could accomplish
Of all that could be mine

Destined to be my destruction
But I would rebuild in time
For every fated ending
Is a beginning of some kind

I am grateful for your refusal
To love me the way I deserve
I was destined to be so much more
Than somebody else's reserve

In my cocoon of transformation
Dormant gifts slowly unveiling
One day I will emerge anew
From this chrysalis of healing

# Saviour

Sitting patient by the window
Spinning dreams of love and fame
Eyes searching eagerly
And yet, nobody came

"Only then, will my desires come true
My joy I'll finally claim
Then I'll be fulfilled, be free!"
But still, nobody came

Wishing away the distance
From this moment to the next
Overlooking the subtle seep of time
In anticipation of perfect

The hunger growing in steady pace
With the tightening of my chest
Until this void inside is filled
I cannot safely rest

I must try harder, faster, better
It must be me at blame
My efforts must have lacked someway
That must be why, nobody came

The window grows ever cloudy
Misted by the sighs of my despair
Obscuring the once-bright visions
Of my slowly fading prayer

Sitting patient by the window
Long dried tears stain the window frame
No longer brave enough to ask why
It was me who never came

# Broken Mirror

I was born with a broken mirror
Fragmented. Incomplete
When I look into this mirror
That is all I see

I've gone on many-a pilgrimage
Travelled far, looked deep inside
Drank disillusioned chalices
Promising to restore my pride

Creams to hide those shameful marks
Pills to reshape what is framed
Draw, erase, re-erase
The reflection stays unchanged

Forever comparing
To the posters on my wall
Of girls born with whole mirrors
With no imperfections at all

"One day you will find the glue
To fix those ugly scars
A prince will save you, love you
In spite of who you are"

I waited, I prayed
Head bowed; heart raw
Forever looking in my mirror
Hating what I saw

I threw away that mirror today
That deceitful, cruel, false friend
Who stole my individuality
The punishment now ends

I was born with a broken mirror
What a silly thing to bestow!
Sometimes I stop to wonder
Who broke that mirror at all?

# Sankofa

The proverbial path not chosen
Tomorrow shrouded
By that one mistake

The unfulfilled potential I was born with
That I squandered
A sacrifice I did not need to make

What would you choose?
If you could do it over?
Rewrite the story of who you are

An 'if' misidentified
Left redundant
Obscuring what's in your power

Blindfolded by your eternal damnation
To be stuck
Just because you said, 'no' that day

Opportunity is immortal
It still waits
For you to accept your destiny

Grasp that forgotten cup
Reach out
It's time to recommit

Life is waiting for you
Sankofa.
Go back and get it

CPSIA information can be obtained
at www.ICGtesting.com
Printed in the USA
BVHW032301041022
648707BV00011B/179